LLAMA L A

Christina Rose

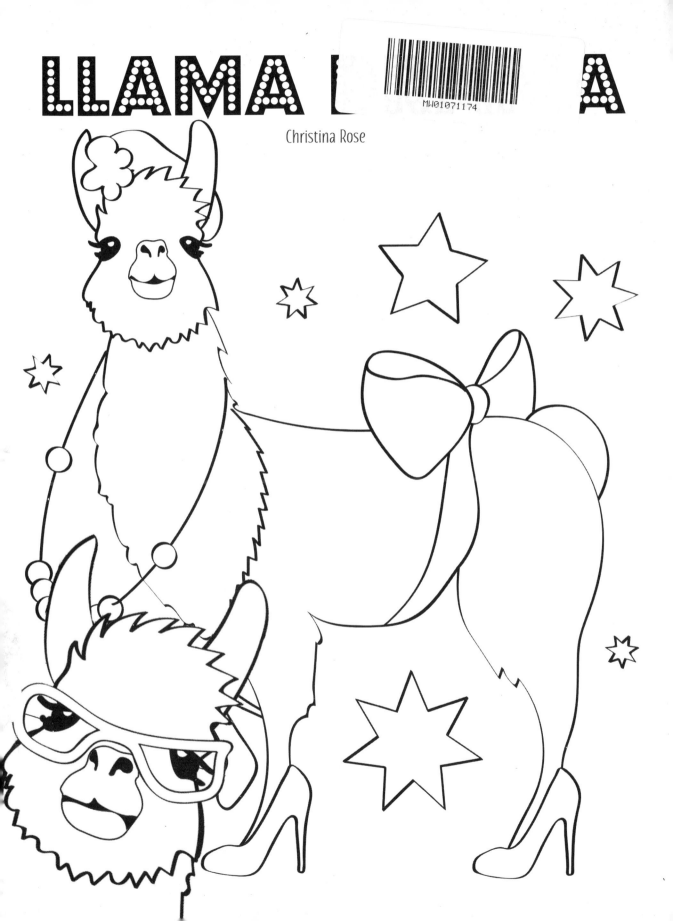

LLAMA DRAMA COLOURING FOR LLAMA LOVERS & DRAMA QUEENS

Copyright © Bell & Mackenzie Publishing Limited 2017

First published in the United Kingdom in 2017 by Bell & Mackenzie Publishing Limited.

ISBN: 978-1-912155-94-1

Created by Christina Rose

BELL & MACKENZIE
PUBLISHING LIMITED
www.bellmackenzie.com

Printed and bound in Great Britain by TJ International Ltd

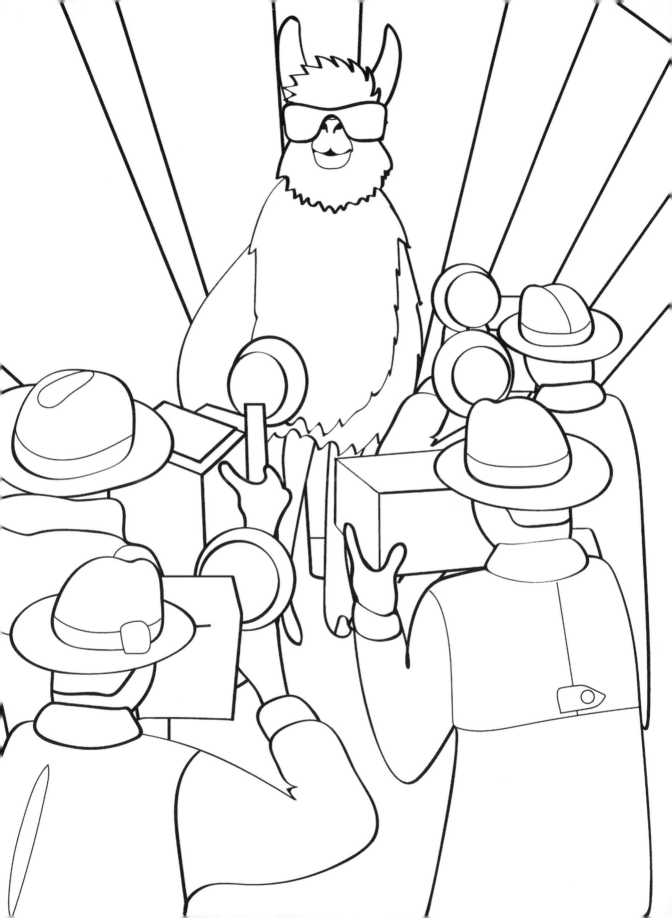

HOW MUCH IS TOO MUCH PIZZA?

NO PROB-LLAMA

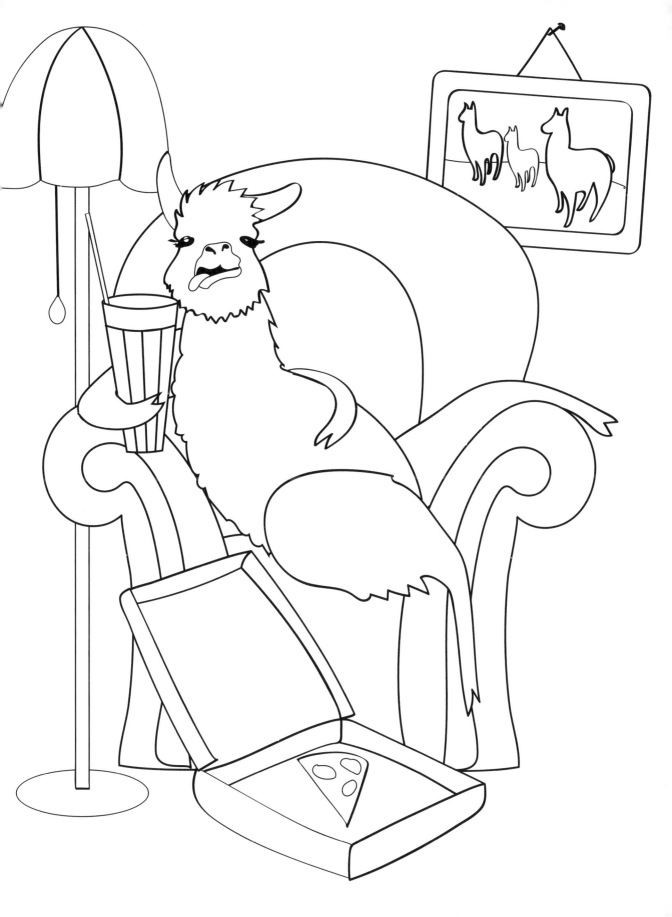

HUGS AND SPIKES FOR FREE

NO PROB-LLAMA

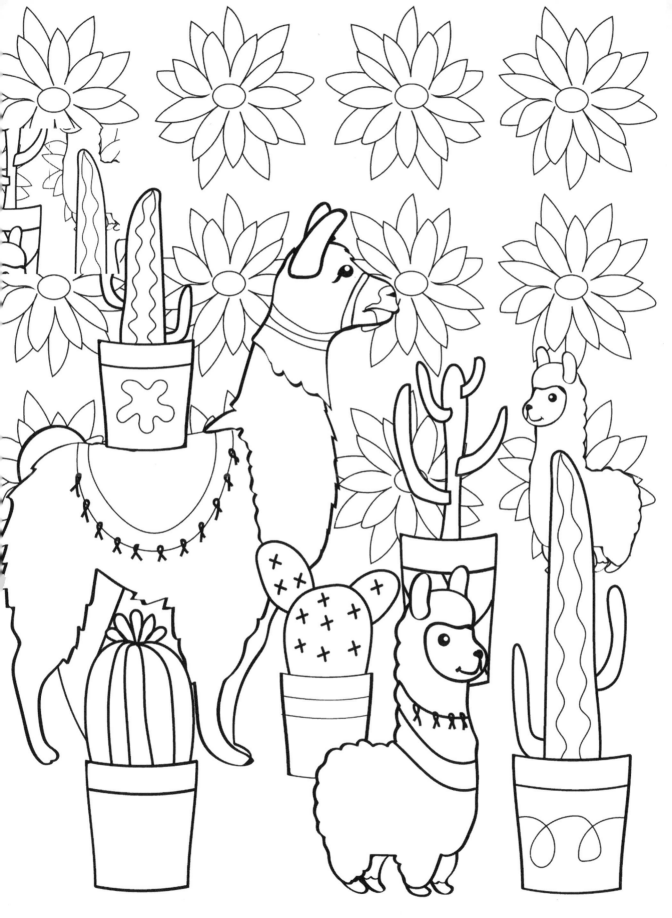

THAT MOMENT WHEN YOU THINK IT'S FRIDAY BUT IT'S REALLY WEDNESDAY

NO PROB-LLAMA

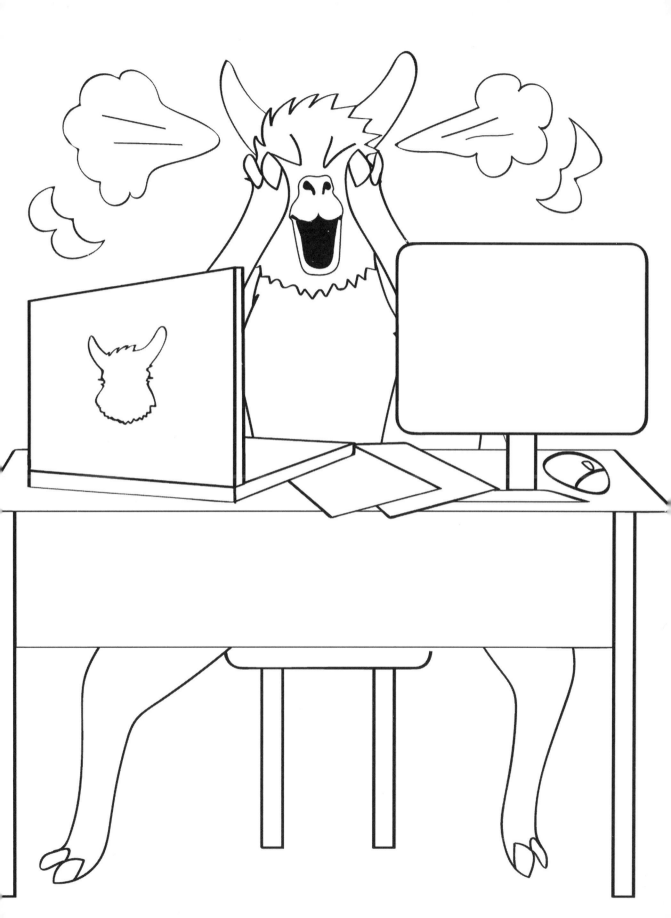

DON'T MAKE ME COME DOWN THERE

NO PROB-LLAMA

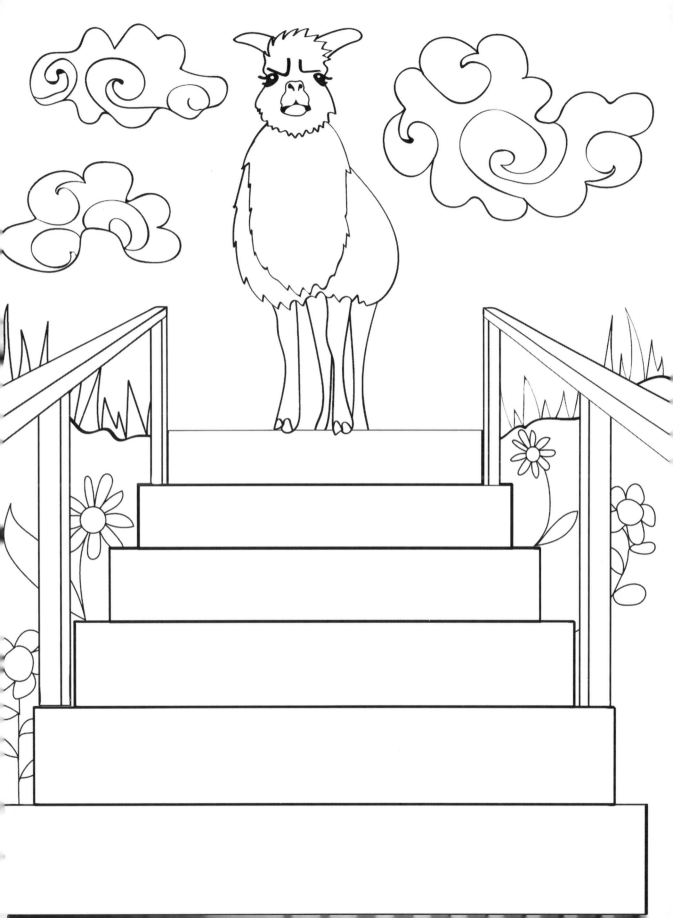

PHOTOBOMB!

NO PROB-LLAMA

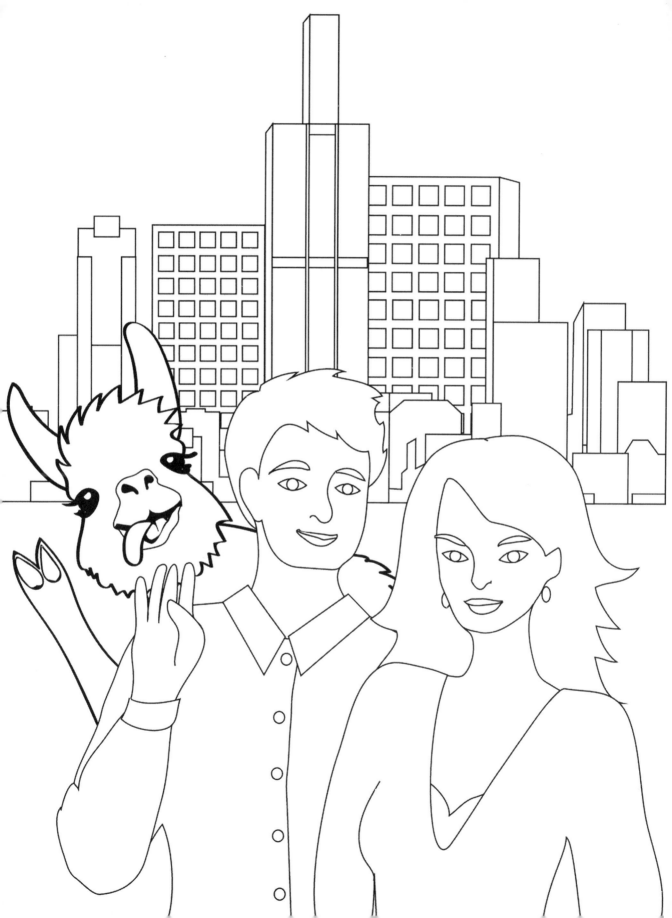

WAITING FOR AMAZON PRIME

NO PROB-LLAMA

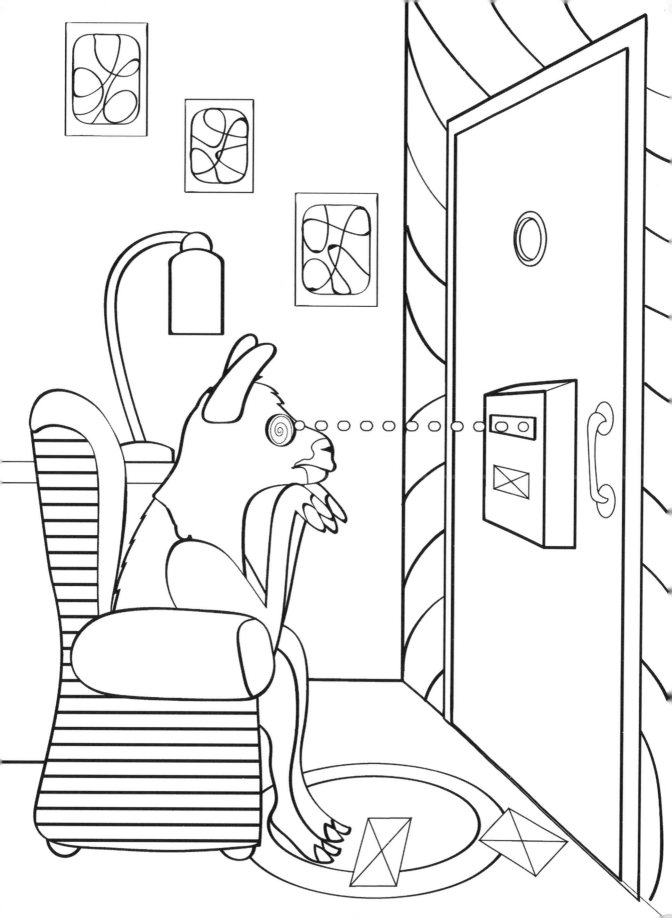

LOOKIN' GOOOOOOOOOD

NO PROB-LLAMA

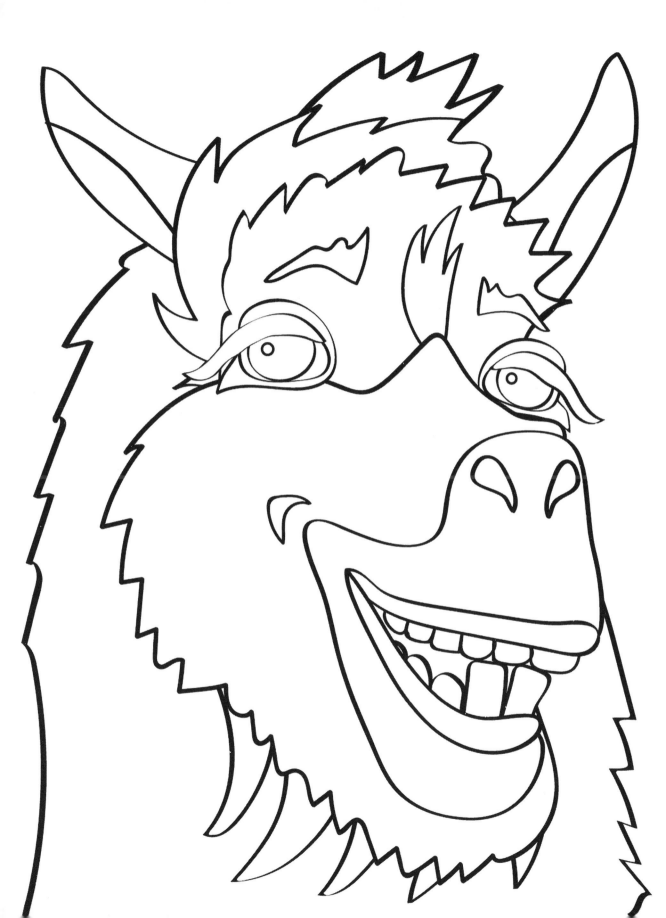

BORN TO RIDE

NO PROB-LLAMA

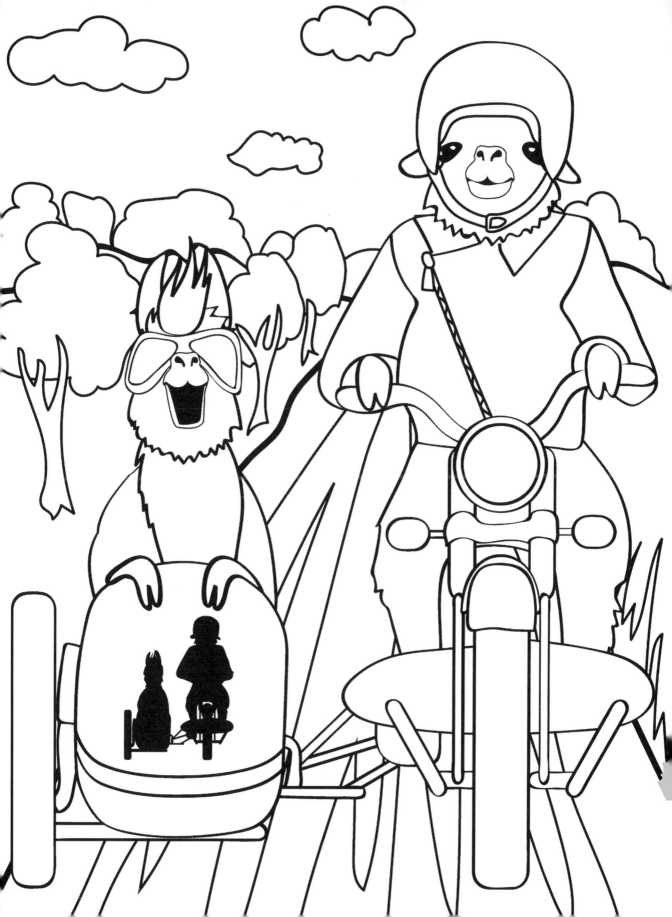

IF I FITS...
...I SITS

NO PROB-LLAMA

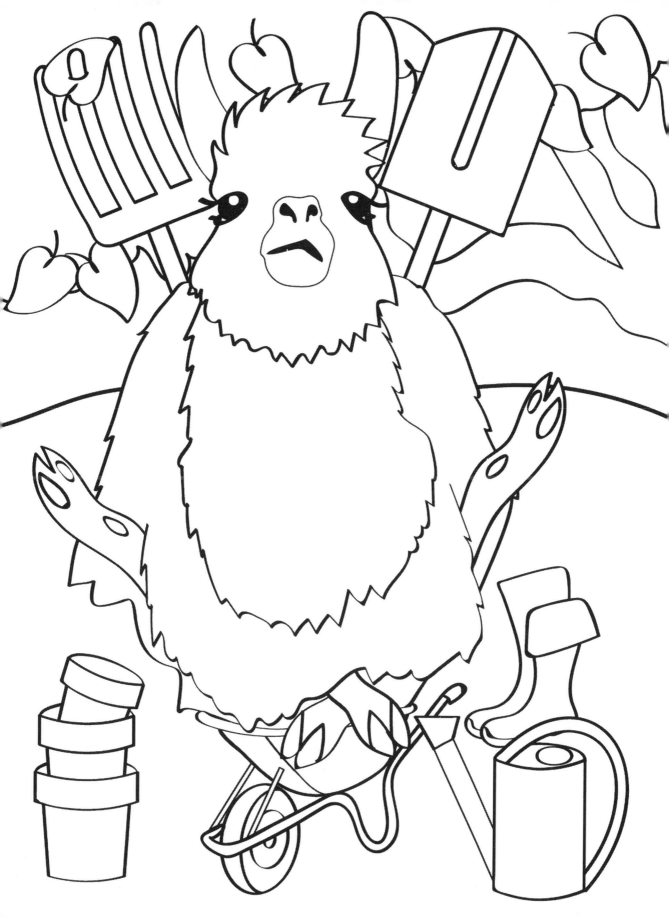

IT'S CALLED FASHION. LOOK IT UP.

NO PROB-LLAMA

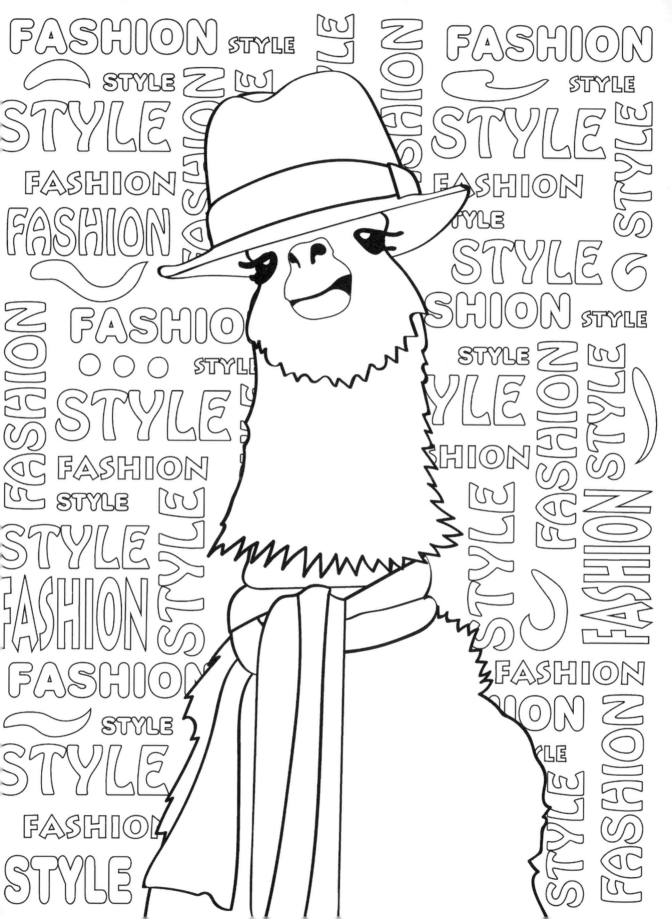

SURFING
LIKE A BOSS

NO PROB-LLAMA

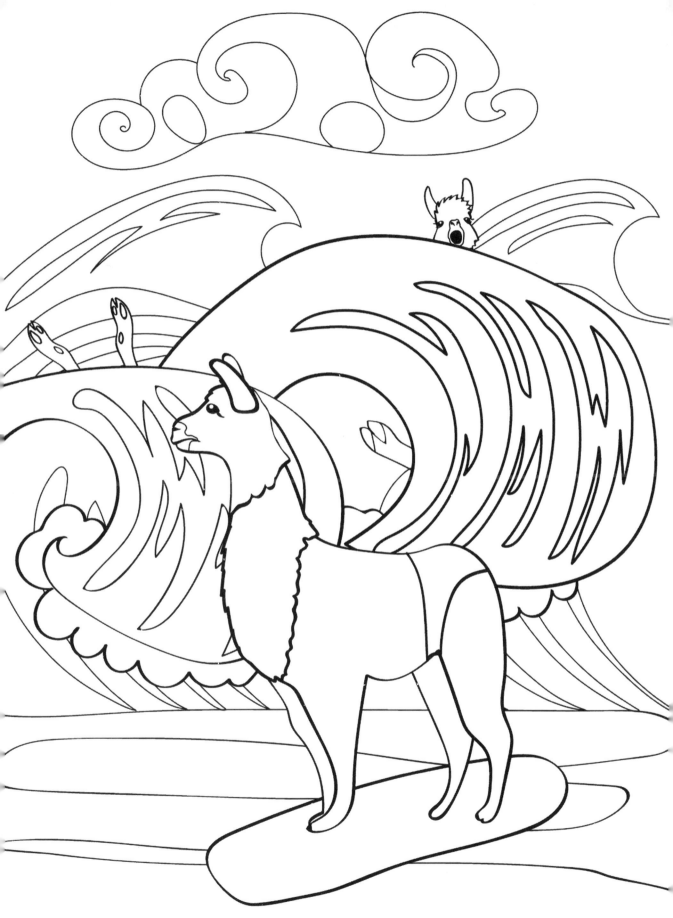

LLAMA-CORNS ARE REAL. FACT.

NO PROB-LLAMA

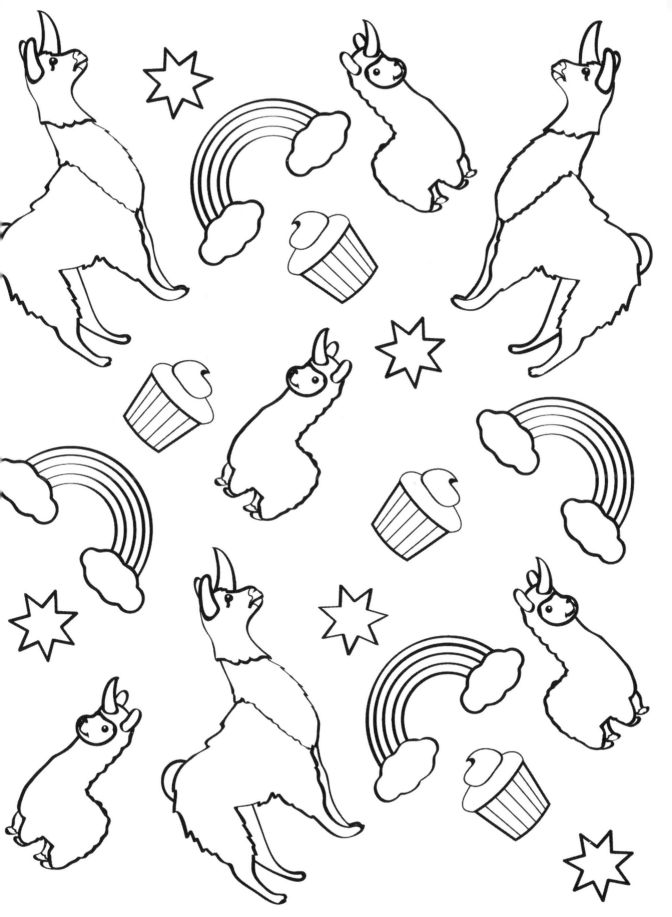

CAN I GET A WOOP WOOP?

NO PROB-LLAMA

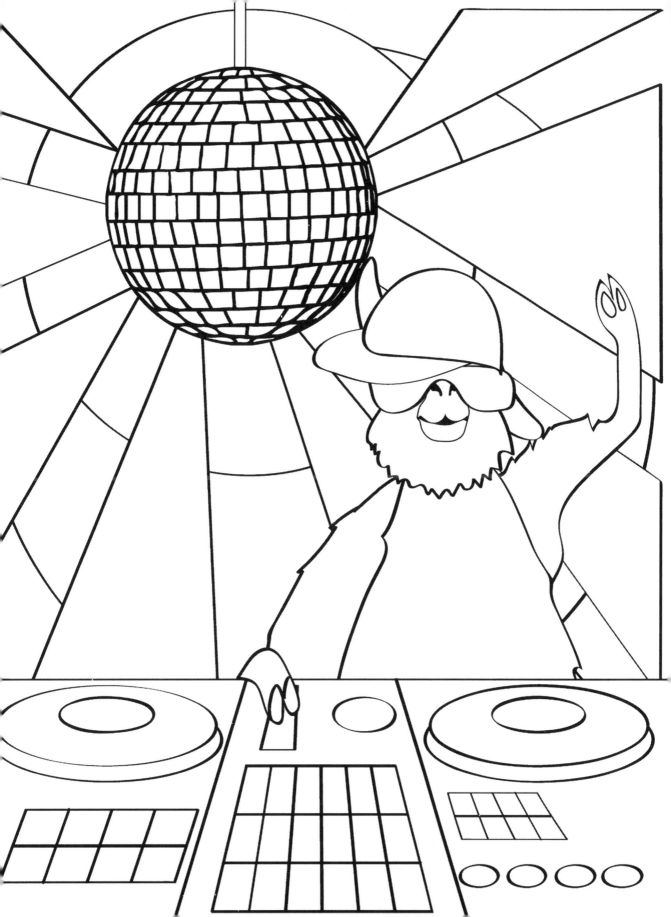

FEELING FABULOUS

NO PROB-LLAMA

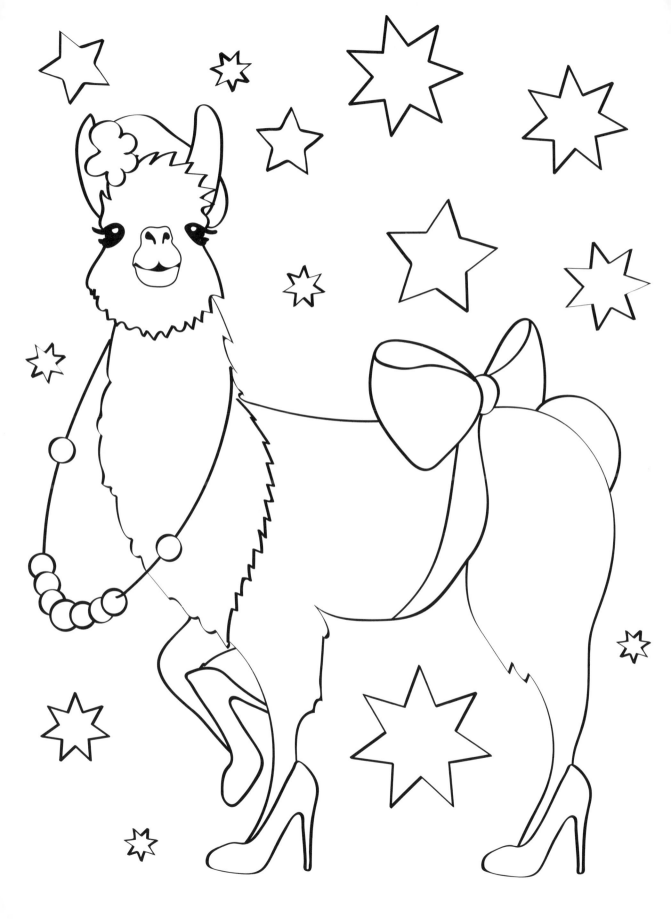

GOING BACK TO MY ROOTS

NO PROB-LLAMA

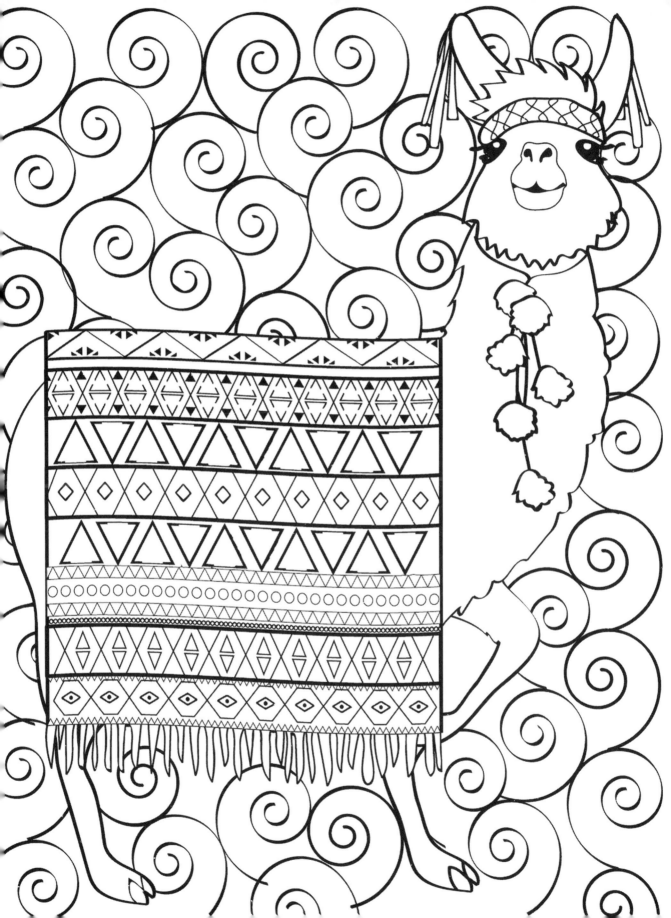

BUT FIRST LLAMA TAKE A #SELFIE

NO PROB-LLAMA

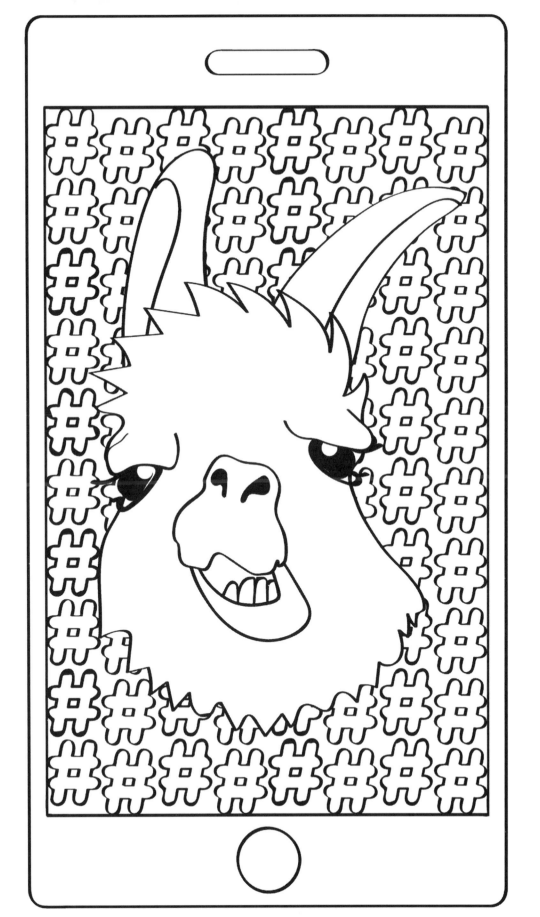

LLAMAS IN PYJAMAS

NO PROB-LLAMA

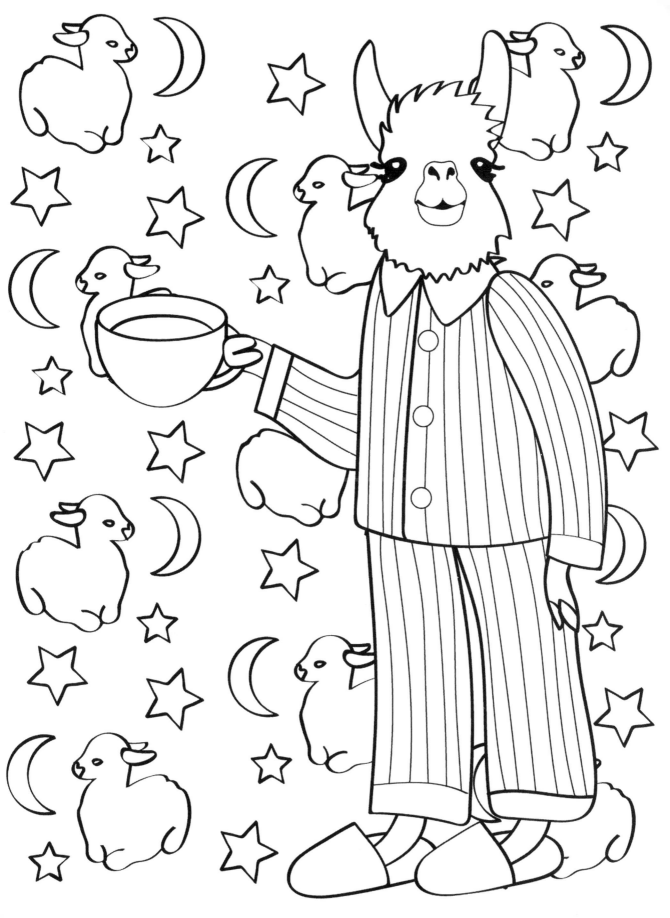

FA LA LA LA LA LA LA LA LLAMA

NO PROB-LLAMA

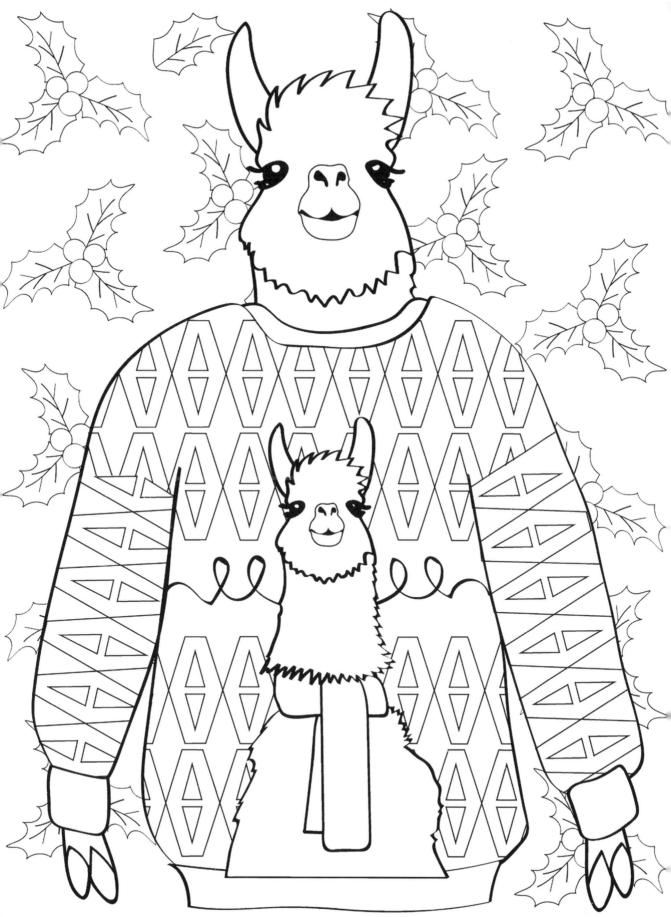

HAPPY BIRTHDAY.
HAVE A LLAMA FUN.

NO PROB-LLAMA

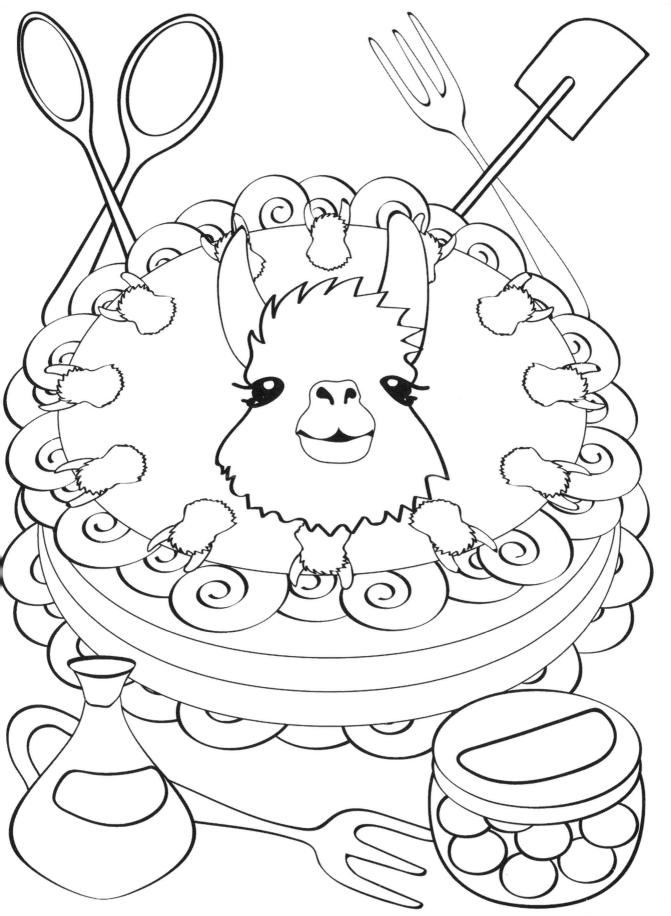

FABULEUX À PARIS

NO PROB-LLAMA

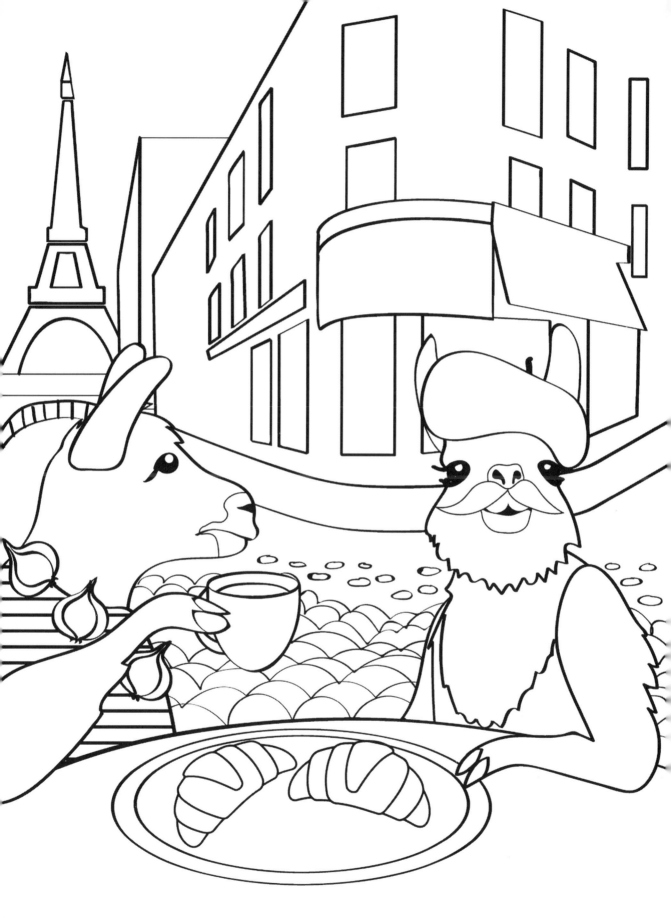

POP IT LIKE IT'S HOT

NO PROB-LLAMA

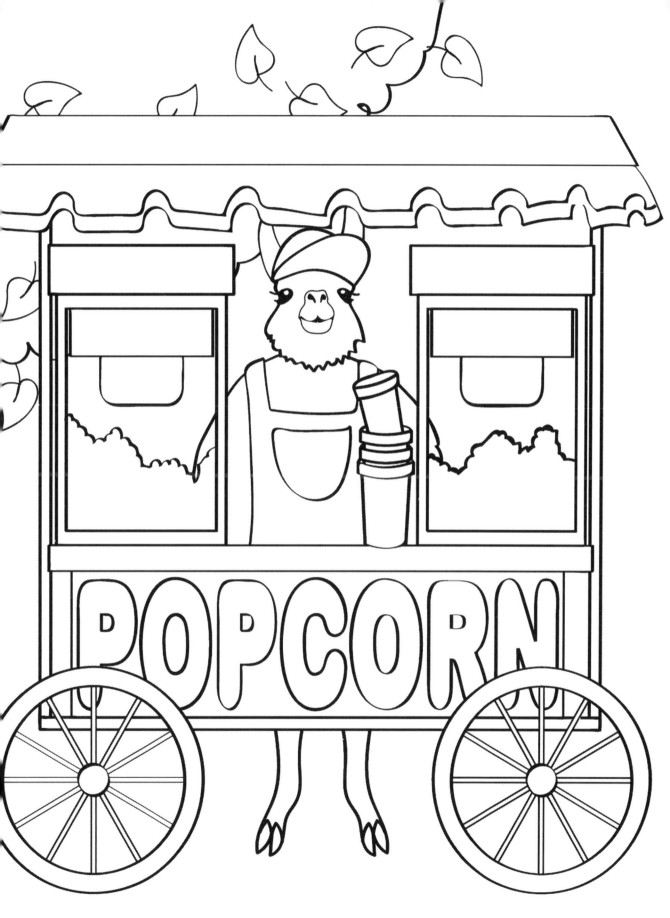

STYLING IT OUT ON THE SLOPES

NO PROB-LLAMA

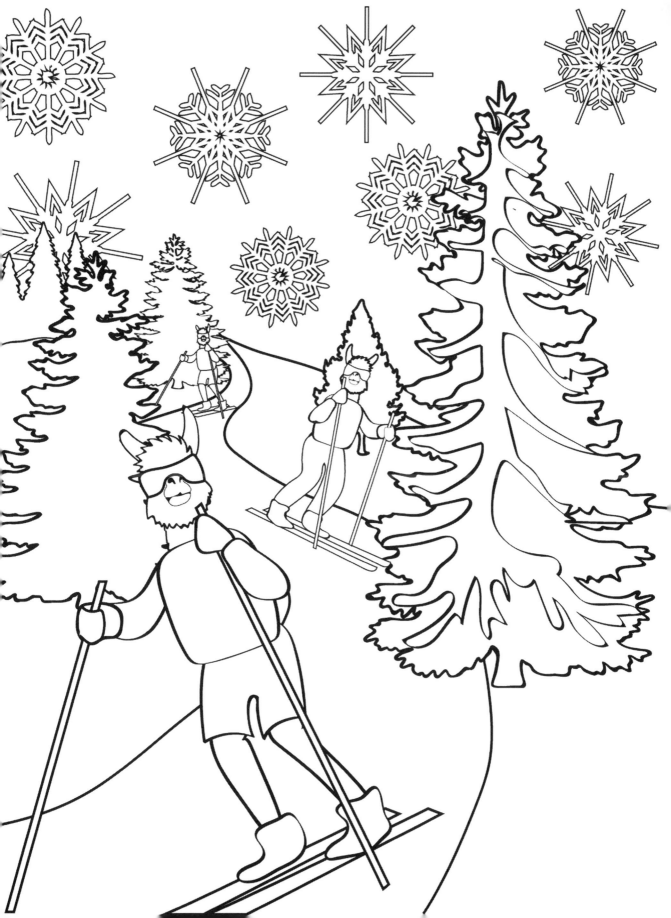

WAKE UP & HULA HOOP

NO PROB-LLAMA

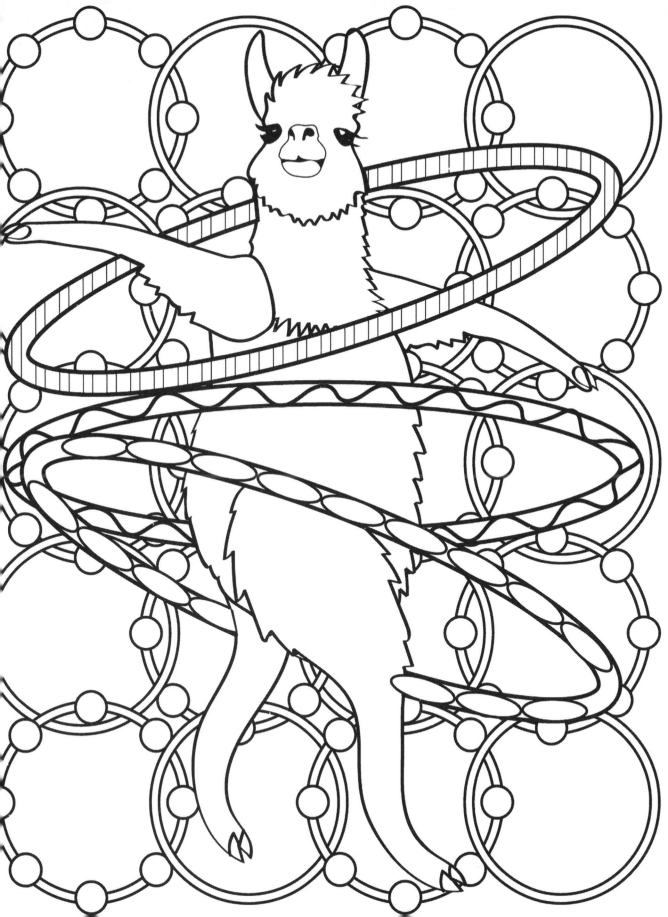

CLUB
TROPIC-LLAMA

NO PROB-LLAMA

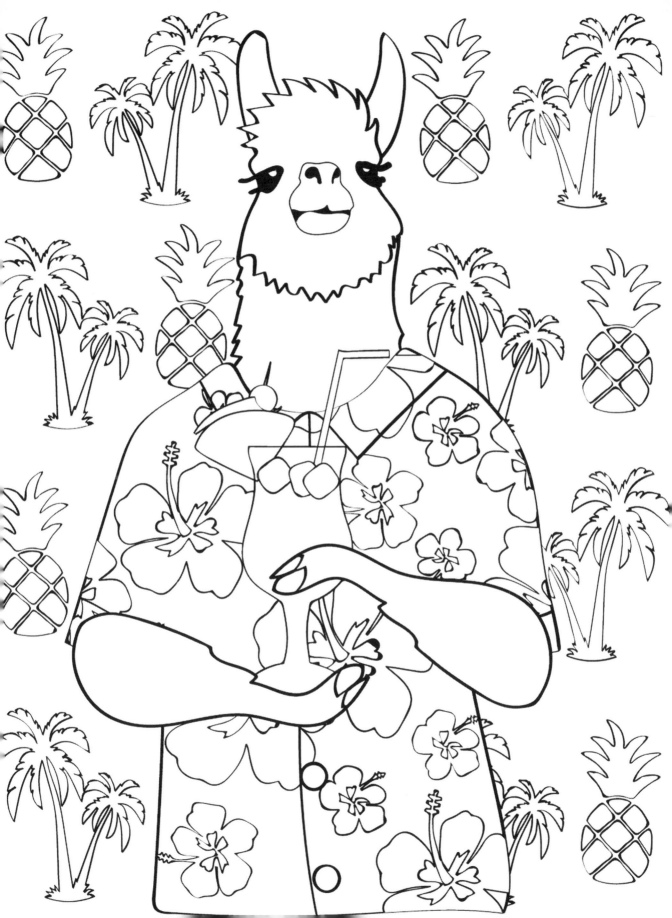

WHY FIT IN WHEN YOU WERE BORN TO STAND OUT?

NO PROB-LLAMA

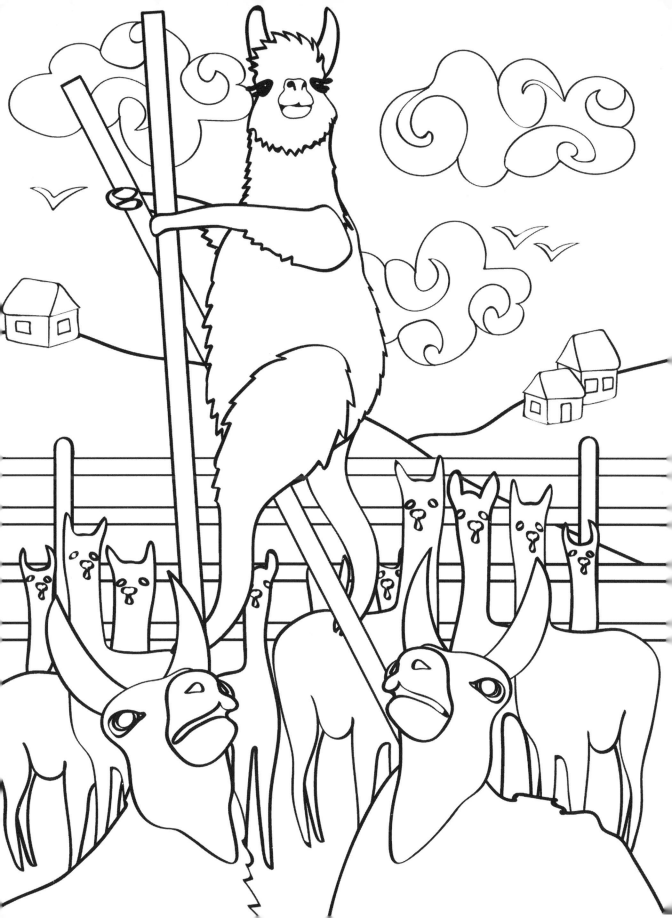

WINNING ISN'T EVERYTHING... IT'S THE ONLY THING

NO PROB-LLAMA

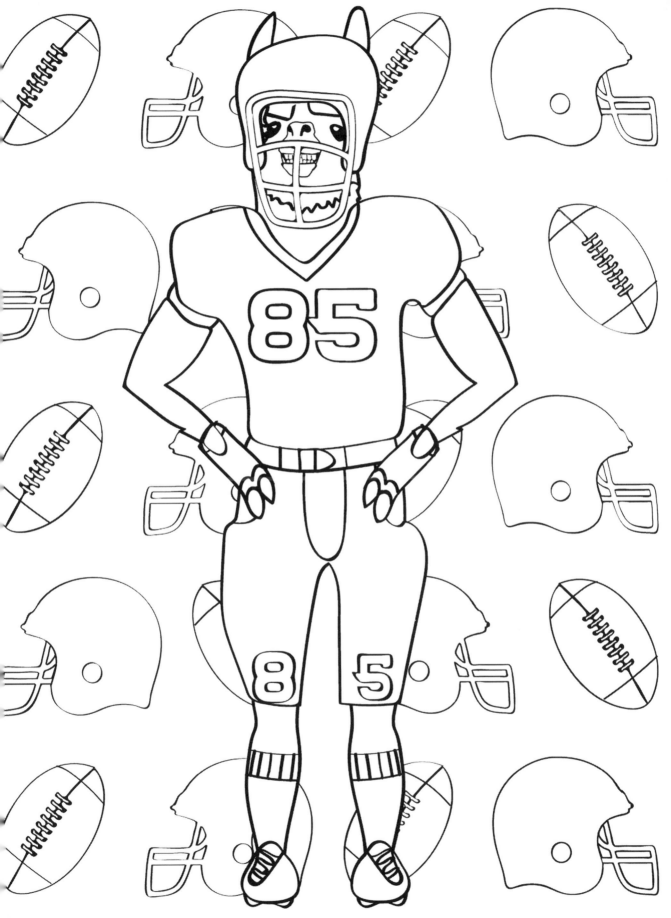

COME FLY WITH ME

NO PROB-LLAMA

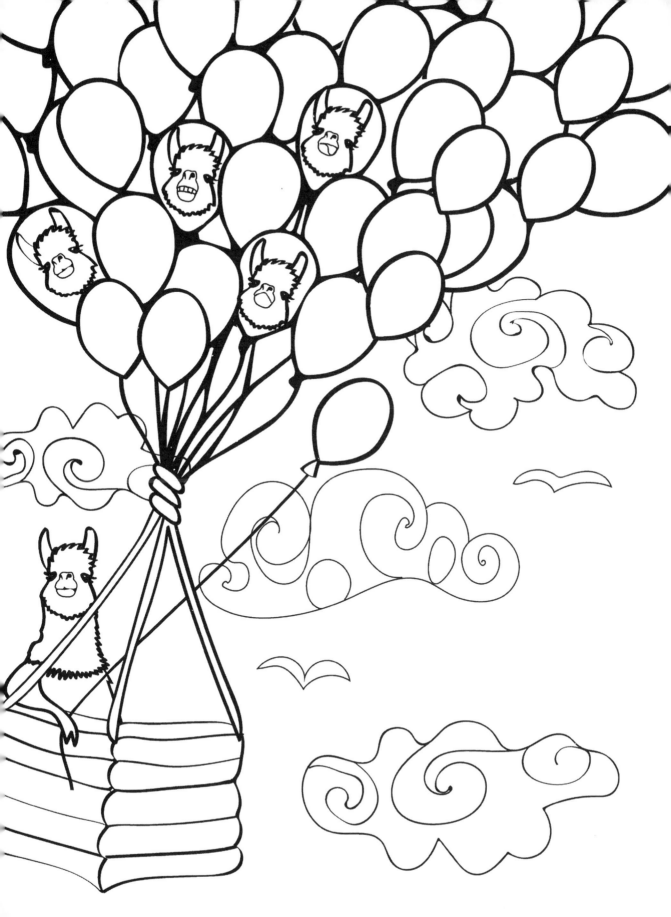

FORGET FAKE NEWS

FAKE NEWS

NO PROB-LLAMA

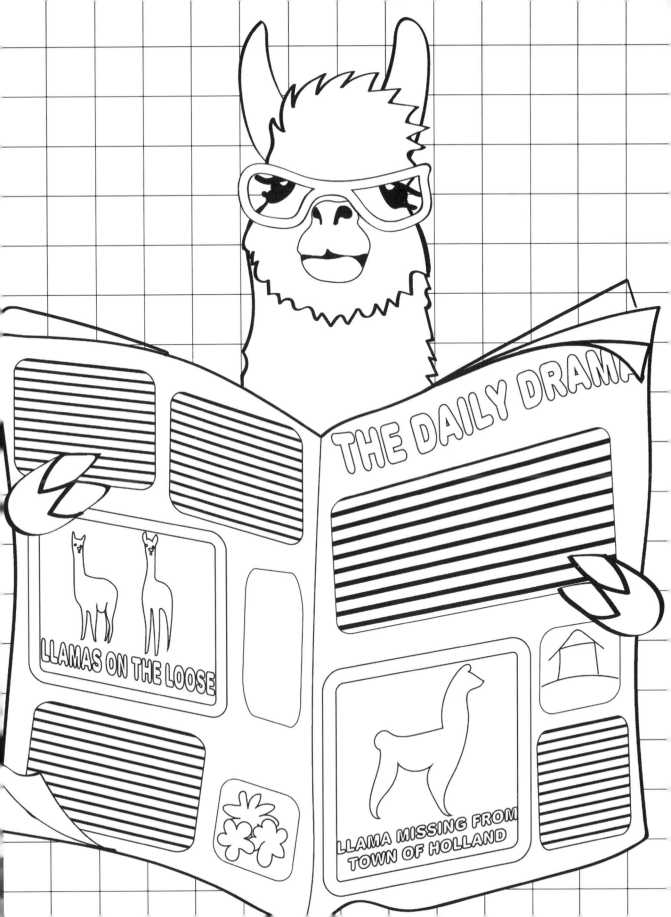

CHIC

NO PROB-LLAMA

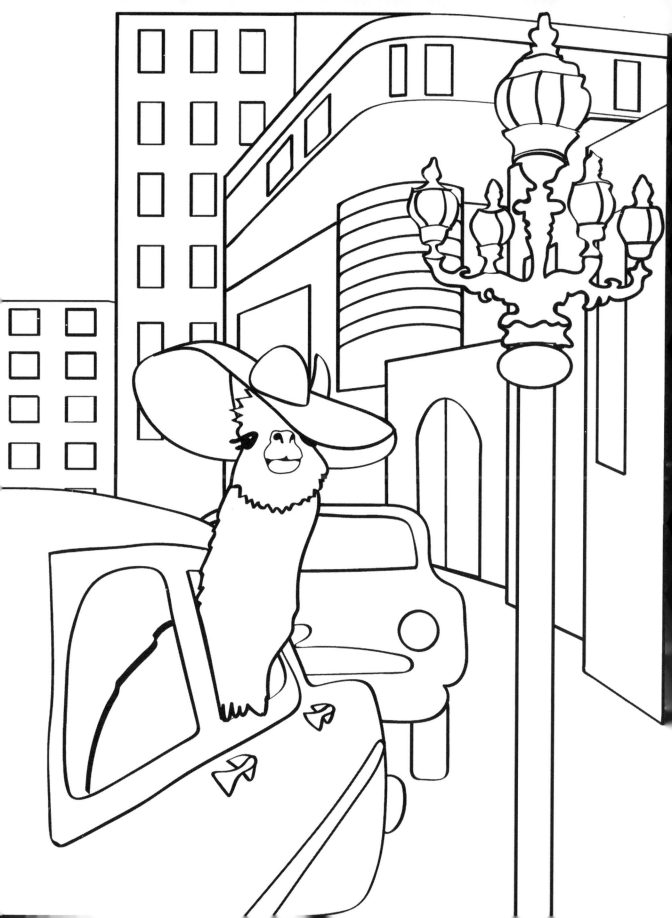

FABULOUS WORKS EVERYWHERE

NO PROB-LLAMA

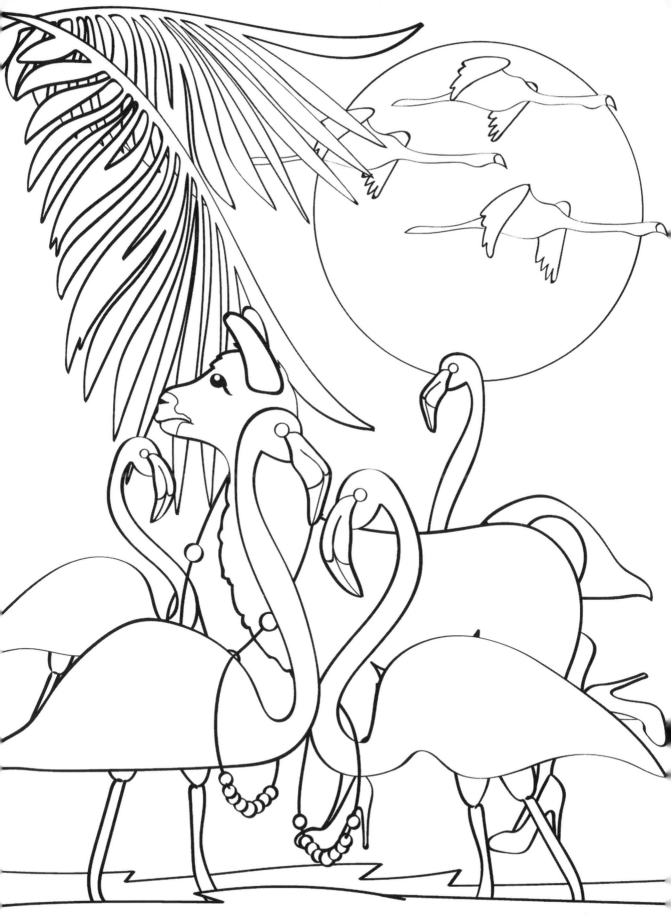

J'TAIME

NO PROB-LLAMA

THIS LLAMA RUNS ON LOVE, LAUGHTER AND STRONG COFFEE

NO PROB-LLAMA

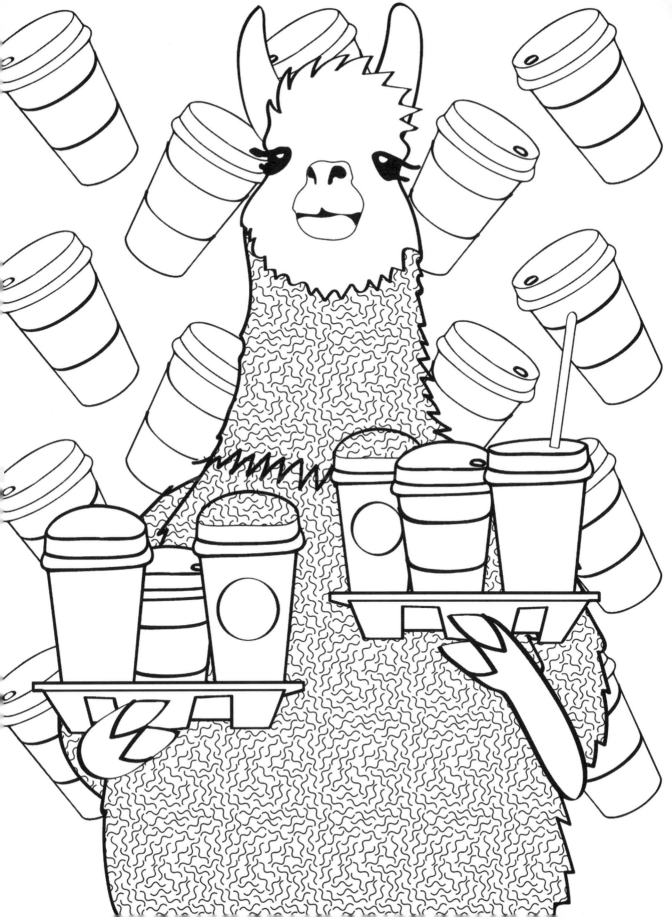

LLAMA LEGGIERO

NO PROB-LLAMA

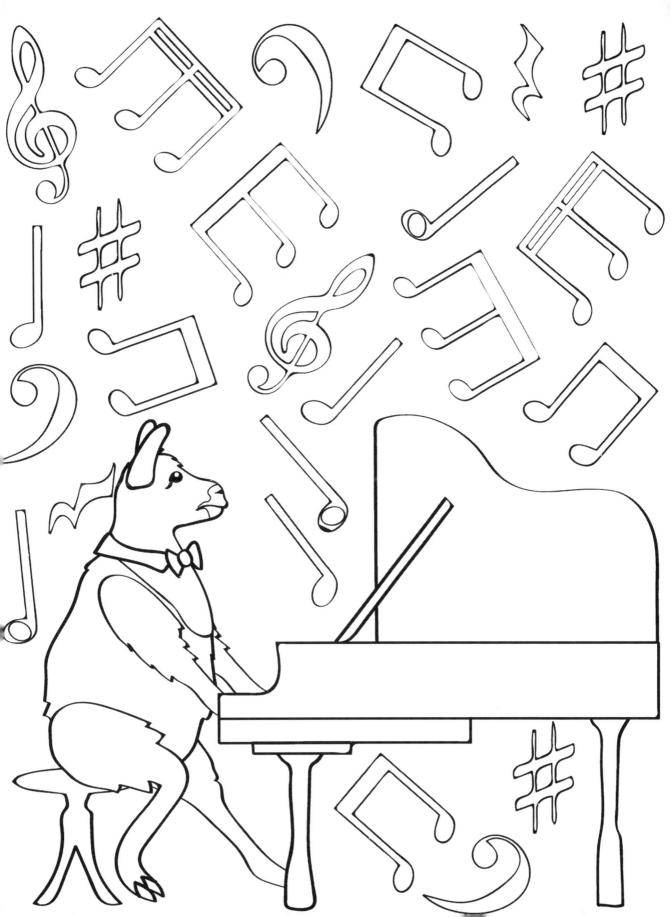

LLAMA LOVE

NO PROB-LLAMA

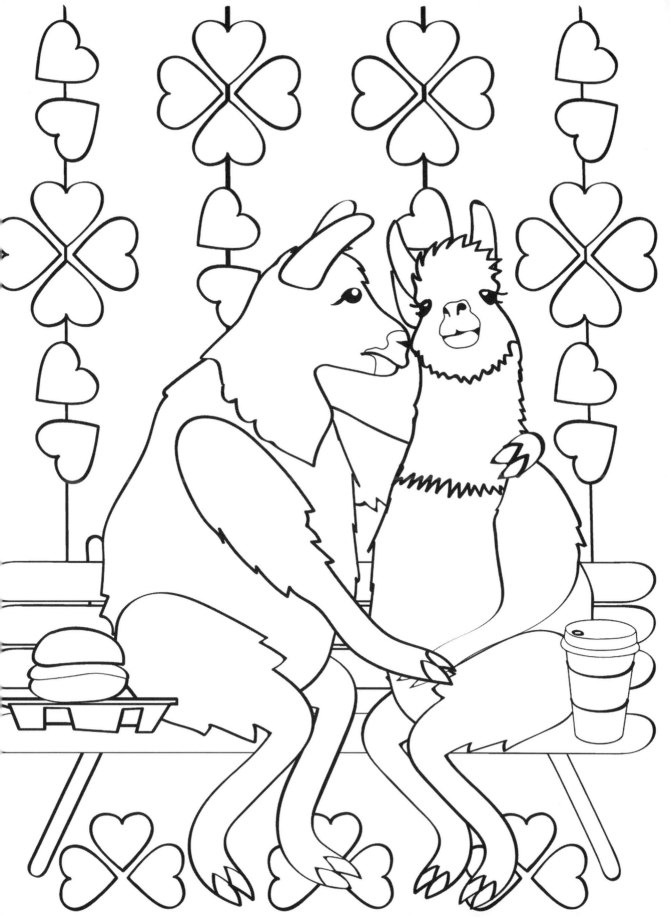

KONNICHIWA

NO PROB-LLAMA

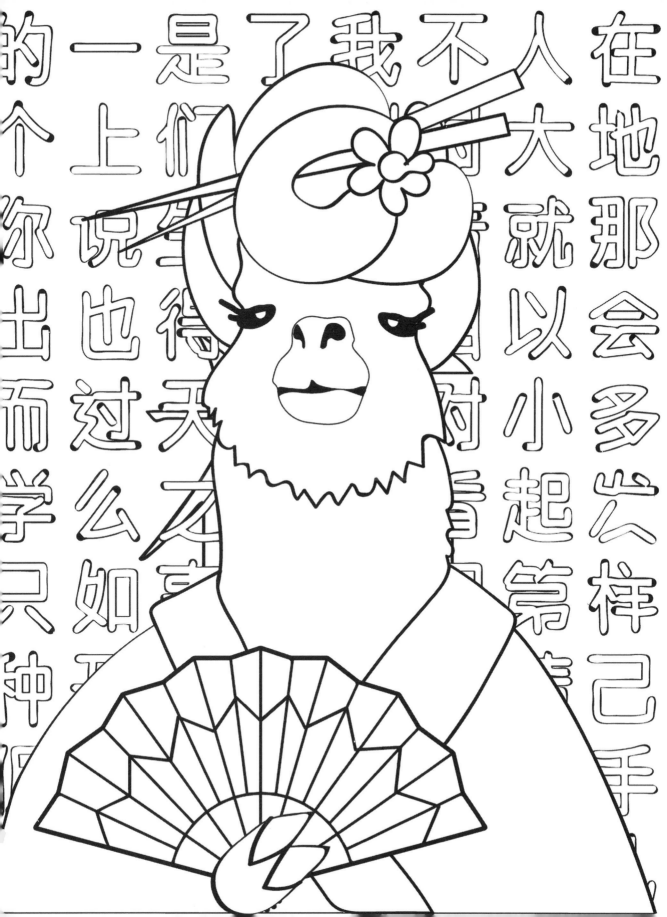

DID YOU JUST SAY CHEERLEADING ISN'T A SPORT?

NO PROB-LLAMA

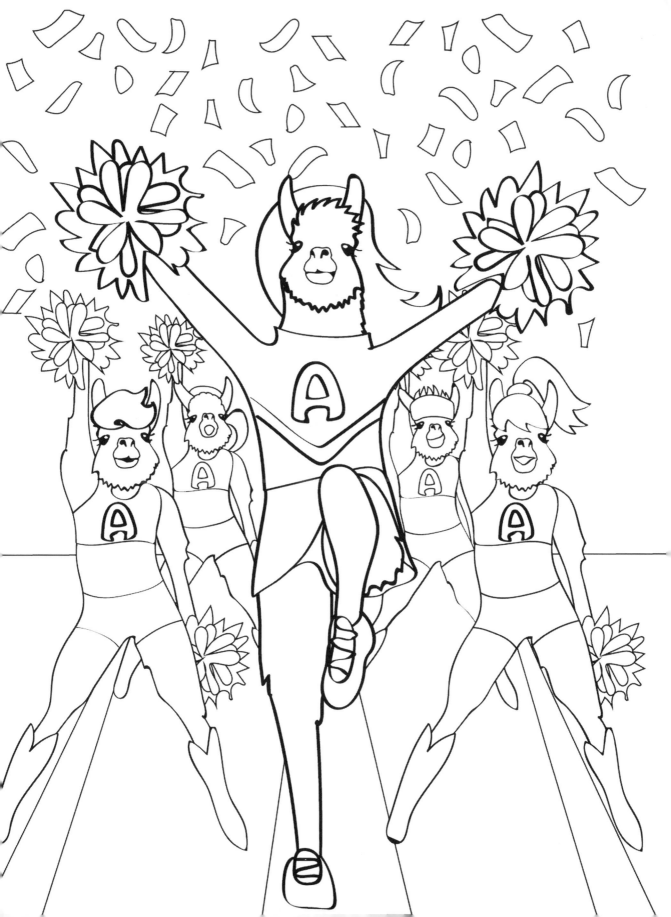

DONUTS......
ANY EXCUSE TO
EAT CAKE FOR
BREAKFAST

NO PROB-LLAMA

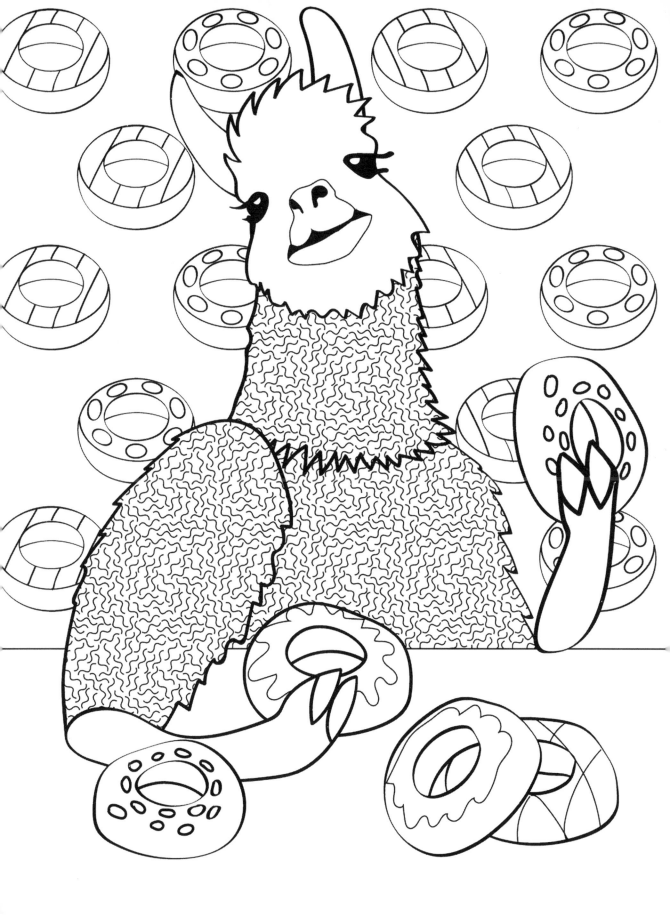

YOU CAN'T HANDLE A DAB THIS BIG

NO PROB-LLAMA

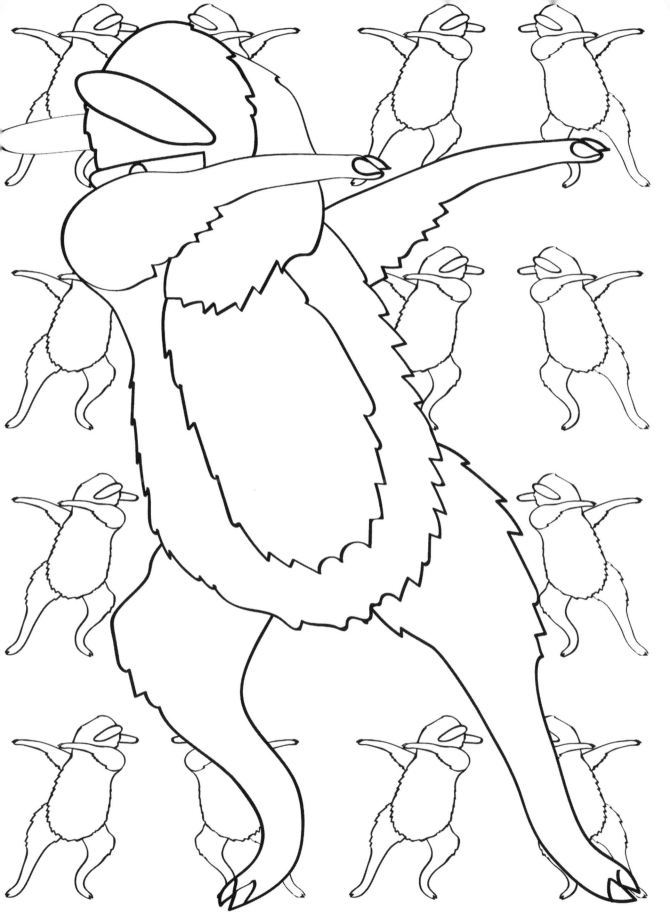

CHANNELING THE DALAI-LLAMA

NO PROB-LLAMA

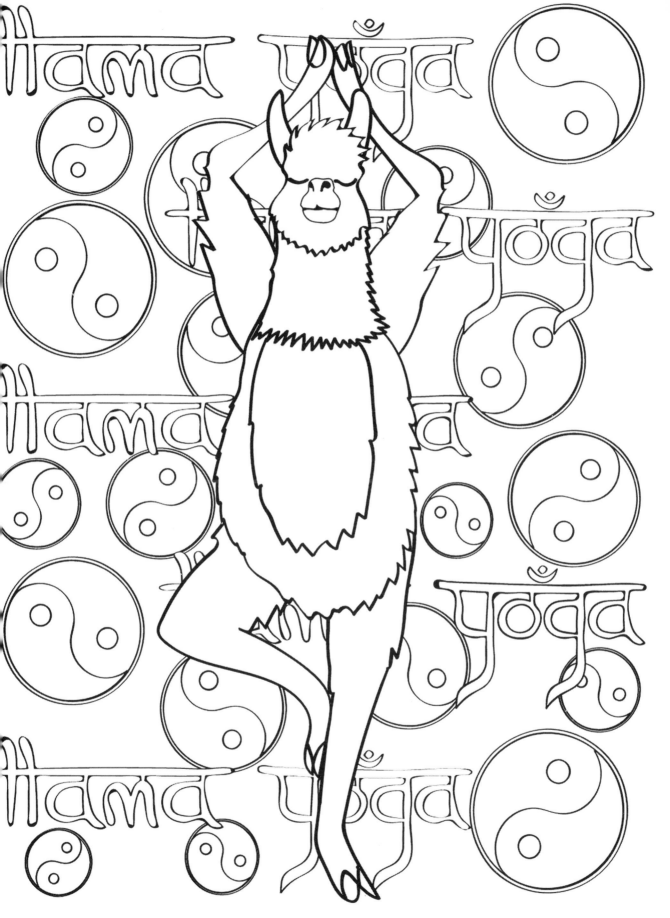

IT'S BEGINNING TO LOOK A-LLAMA LIKE CHRISTMAS

NO PROB-LLAMA

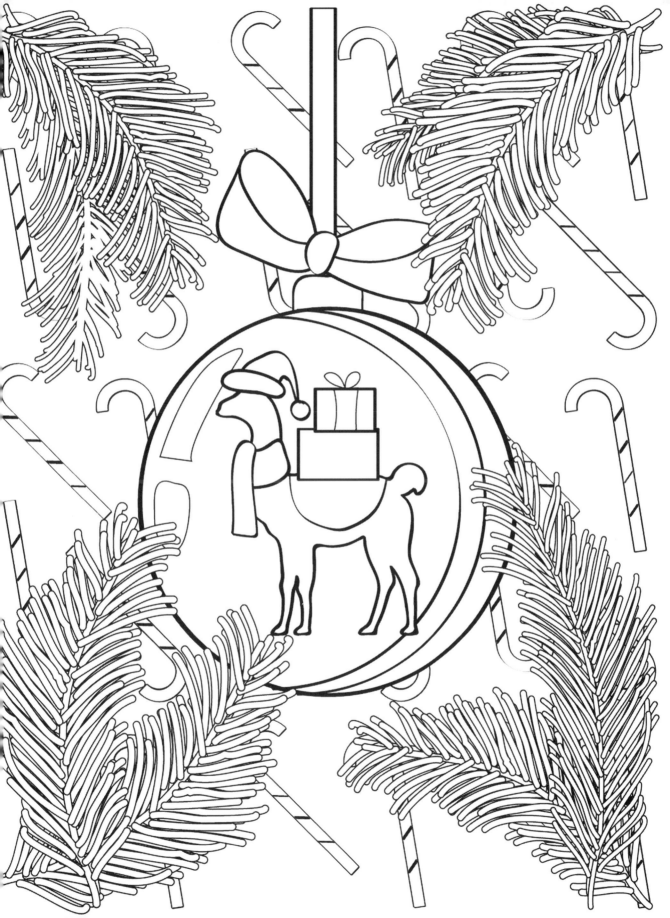

PEOPLE BE LIKE... I'LL HAVE THE SALAD

NO PROB-LLAMA

WHAT IF DISCO ISN'T DEAD?

NO PROB-LLAMA

I'M LOVIN' IT

NO PROB-LLAMA

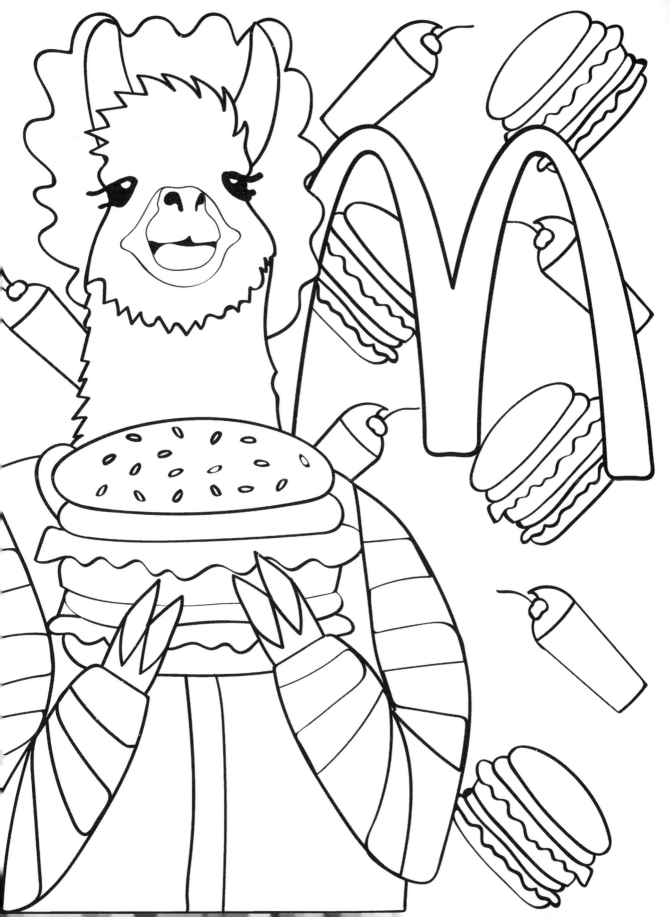

PUG LIFE

NO PROB-LLAMA

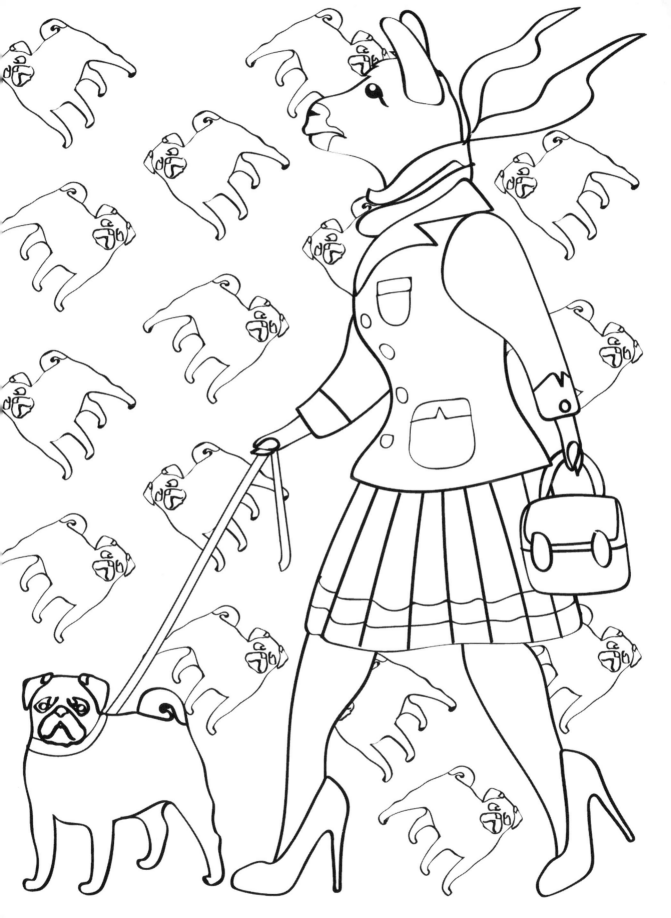

BOOTS, CLASS & A LITTLE SASS. THAT'S WHAT COWGIRLS ARE MADE OF.

NO PROB-LLAMA

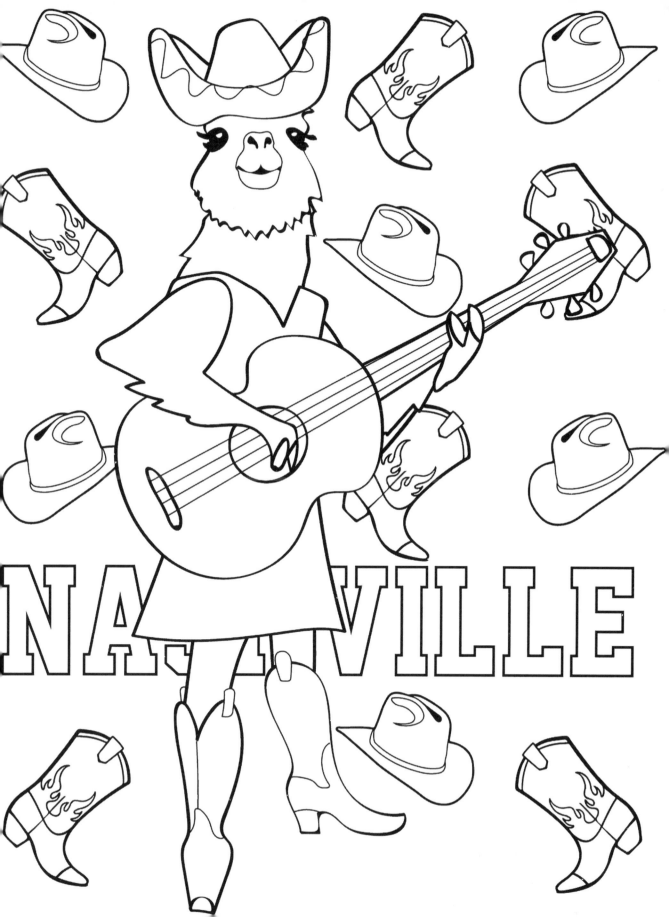

CHAPLIN STYLE

NO PROB-LLAMA

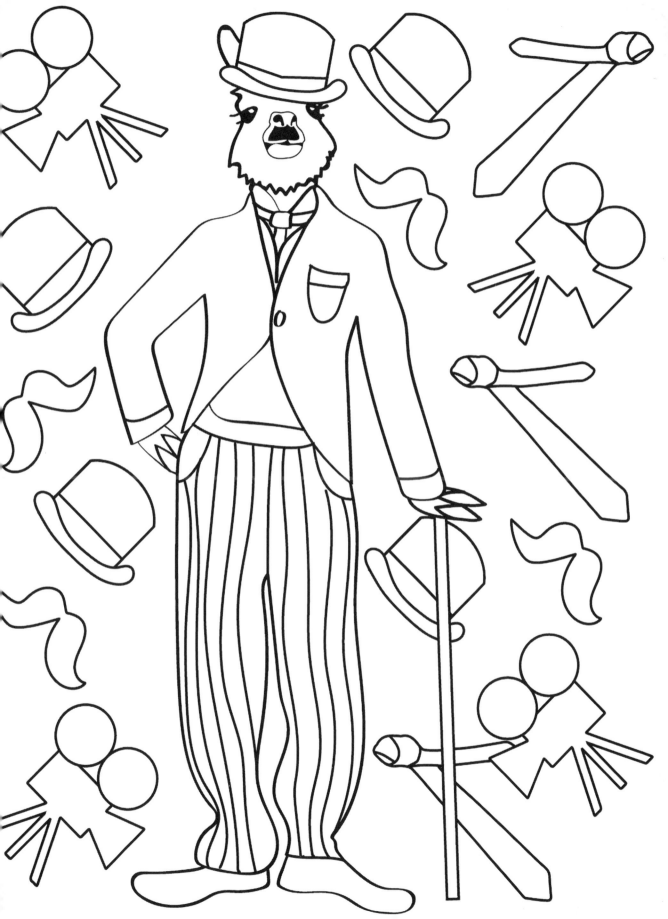

YOU MAY ALSO ENJOY...

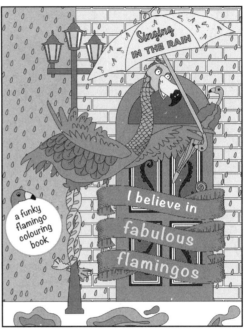

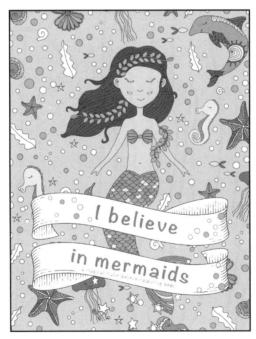